Introduction to Imaging

Issues in Constructing an Image Database

Howard Besser
Jennifer Trant

Foreword

The distribution of digital images over communications networks will make our cultural heritage available to a wider audience than ever before. Creative use of digital-imaging technology has the potential to change the nature of teaching and research. For these transformations to take place, however, a critical mass of digital information about works of art must exist, and it must be available in standard forms. A common understanding of the principles and issues that pertain to the creation and distribution of digital-image archives is required for this new field of activity to move ahead as a whole. In an area where the terminology and procedures are unfamiliar and where technology evolves rapidly, a basic outline of the issues and practices involved in creating a digital-image database is essential.

This book introduces the technology and vocabulary of digital imaging as they relate to the development of image databases depicting works found in museum collections. It illustrates the choices that must be made when images are captured, and outlines the areas in which institutional strategies regarding the use of imaging technologies must be developed.

The Getty Art History Information Program (AHIP) has launched the Imaging Initiative to facilitate the development of common standards that are essential for sharing and preserving digital images and associated information and to explore various means of protecting and administering intellectual property rights to images. Understanding the potential for imaging technology is the first step toward bringing its full benefit to the arts and humanities. As the activities of AHIP's Imaging Initiative continue, we look forward to working with the community to devise shared solutions to common problems, based on a commitment to the interchange of information by means of standards-based open systems.

Eleanor Fink

Director
Getty Art History Information Program

Contents

Technical terms shown in **boldface** in the text are defined in the *Glossary*.

Introduction

Few technologies have offered as much potential to change research and teaching in the arts and humanities as digital imaging. The possibility of examining rare and unique objects outside the secure, climate-controlled environments of museums and archives liberates collections for study and enjoyment. The ability to display and link collections from around the world breaks down physical barriers to access, and the potential of reaching audiences across social and economic boundaries blurs the distinction between the privileged few and the general public. But, like any technology, digital imaging is a tool that must be used judiciously and with forethought.

To develop a digital-image database, an institution must first create a set of digital images, then relate them to a text database that describes them and their content. Although this process is not especially complex, it entails technologies and procedures unfamiliar to many in the cultural heritage community. *Introduction to Imaging* is designed to help curators, librarians, collection managers, administrators, scholars, and students understand the basic technology and processes involved in creating an image database depicting works typically found in museums. It also identifies the issues that arise in this process and outlines the points at which choices must be made. Areas of particular concern include the integration of an image database with other information resources and museum activities, and the interchange of visual information among computerized systems. As always when dealing with technology, care must be taken to develop a strategy that does not limit or foreclose future options and that offers a likely upgrade path.

The discussion begins with a review of the composition of a digital image, defined here as a **bit-mapped** representation of a work of art or artifact. (Neither the specific issues relating to works of art, plans or diagrams [**vector graphics**] created with a computer, nor those involving images made with different light-wave lengths, such as x-radiographs, are covered specifically here.) The users and uses of an image database are reviewed because they play a critical role in determining its character, particularly in the choice of standards and access points for textual description.

The methods employed to construct an image database are outlined, for they will affect its usefulness. For example, image quality is cumulative; the type of scanner chosen, the means by which the images were scanned, and vigilance in quality control

all contribute to the overall "quality" of a digital-image archive. The integration of the image database into an existing information infrastructure is discussed, both in terms of technology and **network topology**, and in terms of issues and policy. A brief overview of technical standards is given, and areas identified in which research and cooperative development are still needed.

For the director of an institution considering a digital-imaging project, this outline may provide all the detail necessary to appreciate the potential of digital imaging. For those planning a digital-image database, however, this overview is merely a beginning. *Other Resources* are outlined, and additional sources of information are included in the *Bibliography*. Careful and informed choices make preparation for the future possible, and adherence to standards ensures the longevity of both an image-database system and the information it contains.

What Is a Digital Image?

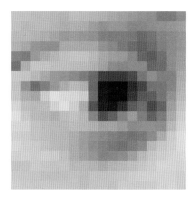

A digital image is composed of a set of **pixels** (picture elements), similar to dots on a newspaper photograph or grains on a photographic print, arranged according to a predefined ratio of columns and rows. The number of pixels in a given area defines the **resolution** of an image. Resolution is a measurement of clarity, or detail, and can refer either to an image file or the device, such as a monitor, used to display it. Image-file resolution is often expressed as a ratio, such as 1000 × 2000; a similar matrix, 640 × 480, for example, is used to characterize monitor displays. Print resolution is more commonly expressed in terms of dots per inch (**dpi**). Image-file resolution and output (print or display) resolution combine to influence the apparent clarity of a digital image when it is viewed *(see Images: Resolution)*.

The full color spectrum

Dynamic range (or **bit-depth**) determines the number of colors or shades of gray (**gray scale**) that can be represented in a digital image. The specific colors used form the image's **palette**. The smallest unit of data stored in a computer is called a bit; dynamic range is a measurement of the number of bits used to represent each pixel in an image (and hence the maximum number of colors or shades of gray in its palette). In a **24-bit image** (sometimes referred to as a **true-color image**) each pixel can represent one of 2^{24} (more than 16 million) possible colors. Eight bits are devoted to recording each of the three additive primary colors: red, green, and blue *(see Images: The Digital Image)*.

The spectrum in 256 colors

In an **8-bit image** each pixel represents one of 2^8 (or 256) possible colors or shades of gray (approximately the quality of NTSC [i.e., U.S.] broadcast television). The color palette can be predetermined by the system, and the same 256 colors (the **system palette**) are used for all images. The appearance of an 8-bit (256-color) image is often enhanced, however, by optimizing the palette used. Specifically selecting 256 colors most representative of those in the work depicted enhances the fidelity of a digital image. Such an **adaptive palette** can cause problems when multiple images are displayed at one time on a system which can only display 256 colors; the system is forced to choose a single palette and apply it to all the images shown at once *(see Images: Dynamic Range)*.

A 256-color palette

Image Capture

Images are converted to digital form using a **scanner**. During image capture, an image is "read" or scanned at a predefined resolution and dynamic range (**digitizing**). The resulting file is then formatted and tagged so that it can be easily stored and retrieved. The image-capture process is very labor-intensive and therefore costly. Image capture, combined with cataloging and indexing, may account for 90 percent of the cost of building an image database.

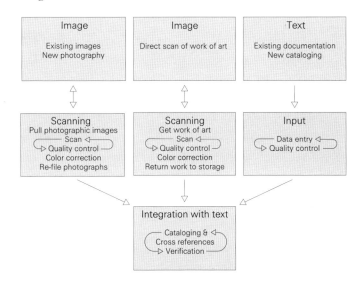

Scanning is a process that generally resembles photography or photocopying. Depending on the type of capture device, the image to be scanned may be placed either in front of a digital camera lens (on a stand or tripod) or on a scanner *(see Selecting Scanners)*. A shot is taken, but instead of exposing the grains on a piece of negative film or on a photocopying drum, light reflects off (or through) the image onto a set of light-sensitive **diodes** (usually as part of a device called a **CCD array**). Each diode responds like a grain of film, reading the level of light it is exposed to, except that it converts this reading into a digital value, which it passes on to digital storage (usually in a frame **buffer**). Color scanning usually entails three separate scanning passes: one each for red, green, and blue. Rather than exposing the entire image at once, the diodes sweep across the source image (like the light sensors on a photocopying machine). The number of distinct readings, taken vertically and horizontally, determines the resolution of the scanned image. The possible number of values that could be represented is the dynamic range of the image.

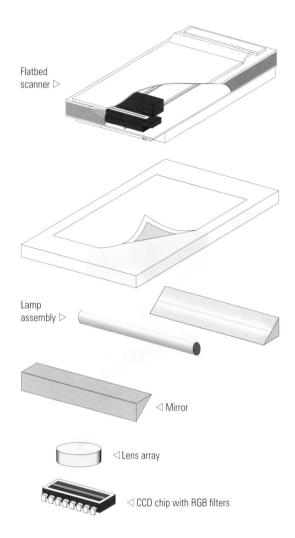

Flatbed scanner ▷

Lamp assembly ▷

◁ Mirror

◁ Lens array

◁ CCD chip with RGB filters

Once an image is scanned, it is converted to a particular file format for storage. There are a number of widely used image formats, such as **TIFF**, **GIF**, **PICT**, **TGA**, **Sun raster**, **CGM**, and the **PhotoCD Imagepac**. Image files include a certain amount of technical information, such as pixel dimensions and bit-depth. This data is stored in an area called the image **header**. Because not all image-file formats can be read by all viewers, a choice must be made to either store or distribute images in a single format, which makes administration easier, or in multiple formats, which support broader access and use.

Because high-resolution digital-image files are very large—a 24-bit **full-screen** image to be displayed on a workstation can occupy 6 megabytes—users often need to reduce the size of image files *(see Compression)*.

Compression

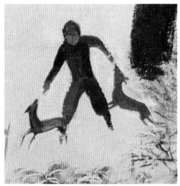

Uncompressed/lossless compression

Image compression is the process of reducing the size of image files by methods such as abbreviating repeated information, or eliminating information that is difficult for the human eye to see. An image decompressed and viewed after **lossless compression** will be identical to its state before being compressed. An image decompressed and viewed after **lossy compression** will differ from its precompressed state because some information will have been eliminated. Commonly used compression formats include **CCITT Group III or Group IV** (used by most fax machines), **JPEG, JBIG**, and **LZW. Subsampling**, i.e., systematically eliminating every second, third, or nth pixel in both height and width, can also reduce image size. All of these methods, except for lossless compression, result in some loss of data and therefore quality *(see Images: Compression)*.

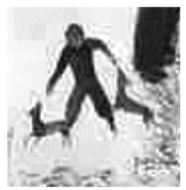

Extreme compression artifacts

Not all images respond to compression in the same manner. As an image is compressed, particular kinds of visual characteristics, such as subtle tonal variations, may produce **artifacts**, or unintended visual effects. Other kinds of images, such as pages of text, compress with minimal visual loss. Some compression schemes, such as JPEG, allow the user to define a particular degree of loss. Through careful testing, a balance between visual quality and file size can be achieved.

Lossless compression typically reduces storage by about 50 percent. Significantly greater storage savings can be achieved if one is willing to compromise some quality by using lossy compression.

The choice of compression format should take into account whether software or hardware to decompress the image is available at the location where the images are to be used.

Various Users, Various Uses

Choice of imaging technology will be influenced by the intended users and uses of the image database. Understanding the needs of users requires probing the assumptions of differing groups. User studies are often segmented by subject area (e.g., Renaissance art, contemporary photography, Buddhist architecture, Roman sculpture); by function or role (curators, art historians, registrars, conservators, faculty, students); or by use (browsing, research, analysis). Specific users and uses may be associated with particular requirements, including a desired level of image quality *(see Image Quality)*, required information-searching facilities *(see Access)*, or a predefined network infrastructure *(see The Working Environment)*. Both current users and uses (i.e., in manual systems), and anticipated future users and uses, should be considered when completing an analysis of user requirements. Future activities could include re-use of digital image files in **CD-ROM** publications, interactive kiosks, **World Wide Web** sites, or as the source for traditional printed output, including postcards, exhibition catalogs, and posters.

The way an image will be used will determine the amount of information it must contain—that is, its required resolution and dynamic range. For example, medium-resolution images of a particular collection may be sufficient for classroom use by undergraduate students, but contain too little information for a conservator exploring the technical construction of a work. A 256-color image may be adequate for recognition purposes, but too inaccurate to support comparative analysis of an artist's palette. An image file that will be used for printed output must be of much higher quality than one used only for on-screen display *(see Image Quality)*.

The functional needs of each class of potential user must also be examined. Will a "scholar's workstation," which supports many research functions, be needed? Will users want to integrate image display with other institutional information? (For example, would users want to display a record from a curatorial research database, or a critique from an on-line journal article, alongside the image?) Would a user want the results of a search of a museum collection-management system to display images for each record? Will users want to integrate image display with various personal information services? (For example, will users want to place images within a word-processing document, or put text records describing images into a bibliography or footnote?) The answers to all these questions will influence the selection of an image-management system.

Within an institution, an image database may need to be integrated with other automated functions (both current and planned) in order to realize its full potential. In such a case, the image database should be incorporated into a general, institution-wide automation plan that takes into consideration hardware, software, operating systems, networks, and overall budgets and priorities. (For example, a Windows-based institution may not be well served by purchasing a Macintosh-based image-database system.) In addition, most museums will want to integrate their image database with existing or planned collection-management systems, on-line public access catalogs (**OPACs**), publishing systems, and/or business or administrative systems. There are many options for passing images and accompanying descriptive information between any of these systems and the image database, and standard means of communicating image and text data between systems need to be established *(see Research Agenda)*.

The information display and processing needs of image-database users must also be identified. Do users require images for browsing (and, if so, what types of identification should accompany each image)? Will they need to view images at various levels of resolution? Would **image processing** or **image manipulation** functions (such as changing colors, zooming, or annotation) be useful? The requirements of users will provide the guidelines for the choice of an image-management system.

Documentation

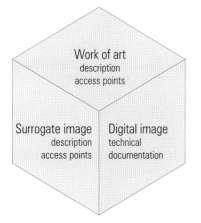

Work of art
description
access points

Surrogate image
description
access points

Digital image
technical
documentation

The images in any image database will need to be accompanied by textual documentation to identify and describe them, and aid in their management. The depth and complexity of this documentation will probably vary from one project to another depending on local policies and user needs. Developers and users of documentation for image databases must distinguish among information that refers, first, to the original work, secondly, to photographic representations of that work, and thirdly to the technical characteristics of a digital image (that may have been captured from the original or a photographic representation, or derived from an existing digital-image file). Careful documentation of **derived images** (created by **subsampling** image files) is essential to manage the proliferation of multiple files depicting the same work in different formats and at different resolutions and dynamic range.

Documentation standards incorporate expertise both in formatting database records for storage or interchange and in using **structured vocabularies** to represent data values for description and retrieval. Data-structure guidelines such as the **Categories for the Description of Works of Art**, defined by the **Art Information Task Force** to represent the point of view of the art historian, provide a framework for data that allows precision, exchange, and re-use of data for multiple purposes. Adherence to common standards will allow information to be shared with other institutions. Standards may even save cataloging and indexing time by making it possible to incorporate portions of documentation records from other institutions into local records.

Content description is information that describes the original work, and does not focus on representations of it. Among the many groups working toward documentation standards for works in museum collections are the Documentation Committee (CIDOC) of the International Council of Museums (ICOM), the Museum Documentation Association (MDA), and the Art Libraries Society of North America (ARLIS/NA).

Access documentation, usually a subset of content documentation, comprises the index terms used to find relevant records within a database. These are often the terms that have been assigned to "searchable fields" within a database structure. Structured vocabularies ensure the consistency necessary for precise retrieval of information *(see Access)*. Sources such as the **Art & Architecture Thesaurus**, the **Thesaurus of Geographic Names**, the **Union List of Artist Names**,

15

ICONCLASS, and the **Library of Congress Subject Headings** provide a wide range of controlled terminology to describe the people, places, things, events, and themes depicted by images.

Some documentation refers specifically to **surrogate images** rather than to original works of art or artifacts. The Visual Resources Association (VRA) Data Standards Committee is developing a set of guidelines for the documentation of surrogate representations of original works of art and architecture. Discussions of issues in this domain frequently appear in the journal *Visual Resources* and on the VRA-L **listserv**.

An emerging concern in documentation is the recording of technical information about the digital image itself. This technical documentation should include details about the scanning process, the **compression** format and ratio, the source of the digital image, and an indication of whether it has been manipulated or **subsampled**. Technical information about the image (such as its file format, dimensions in pixels, and dynamic range) is usually recorded in an image **header**. A header is attached to the captured digital image and forms part of the image file. Currently, the content of image headers is not standard among different file formats.

Accurate technical documentation will improve the long-term usability of an image database. Readily available information about image resolution and compression is critical to image display and **decompression**. Noting the scanner model and scan date will prove important for future **color management** on different display or output devices. Users will also require information about rights and reproductions, image sources, and links to other views and details. The development of standards for image-file description is essential to allow image databases to move readily between computer systems, and to ensure that network-accessible images travel with adequate identifying information *(see Research Agenda)*.

Access

Browsing a large number of images is impractical and inefficient, so most searches of image databases begin with text-based queries. Even if images are categorized, a preliminary search is often necessary to reduce the size of the initial set retrieved. Different groups of users will use different criteria in order to retrieve the images they are seeking. Before description and indexing standards are adopted, criteria of importance to particular kinds of users must be identified *(see Various Users, Various Uses)*. Image-database software may predetermine or restrict which fields are searchable (i.e., act as **access points**); if so, an understanding of access needs becomes a critical evaluation factor in choosing a system. Full-text searches offer a flexible way to search within or across databases, but may sacrifice precision in results.

In the future, it may be possible to retrieve images on the basis of visual criteria. Current research into **pattern recognition** may prove fruitful, making it possible to retrieve images by colors or iconic shapes, or by the position of elements within the image frame. Stock-photo houses that cater to the advertising industry have had some success in using **automatic indexing** to answer such queries as "Find images with shades of blue in the top part of the frame and shades of green in the bottom part" (landscapes). These systems are still in the early stages of development, however, and are not in widespread use.

Offering access to an image database requires careful consideration of the legal issues associated with the use of images. Issues of intellectual property rights are very complex, and many questions must be answered before an image database is created. Does the institution have the right to reproduce the image electronically for display by the user? Under what conditions do users have the right to print or **download** that image? How can the rights to the image be protected? Should the frequency of use of each image be tracked by user group? Should text defining restrictions on use be displayed with each image? Should **digital fingerprints** or **watermarks** be embedded into each image to make it possible to track subsequent unauthorized use?

Before an image is converted to digital form, the right to reproduce it electronically for user display must be acquired, or the public-domain status of the work must be verified. (Simple possession of a work or a reproduction does not necessarily give its owner electronic reproduction or distribution

17

rights.) The conditions under which users may view, print, or download each image must be determined and a system built that enforces those rules.

Text defining restrictions on use may be displayed next to each image, or users may be required to acknowledge restrictions on use. It is possible to employ technical measures to help avoid unauthorized use *(see Security Policy and Procedures)*, but, as a practical matter, owners may prefer negotiating the use of images through license agreements rather than depending on technology to prevent use, or resorting to the courts after an infraction has occurred.

Selecting Scanners

The scanning process is labor-intensive and costly, requiring a significant investment in handling and processing works of art or their **surrogate images**. Materials must be brought to the scanner, lighting set up, the material centered, lens focal length changed, the scan made, material returned to its proper location, and adequate documentation maintained throughout the process. Given this level of effort, it would be wasteful to digitize any body of material repetitively. Images of sufficient quality (high resolution and dynamic range, and consequently very large file size) should be captured to enable a wide range of uses. However, the resources required to provide high-quality images on-line are currently beyond the financial and technical means of most arts organizations. One strategy is to capture an image at a very high image quality and keep the captured image as an **archival image**, storing it off-line on a cheaper storage medium such as magnetic tape or CD-ROM. Techniques such as **lossy compression** and **subsampling** can then be used to derive a smaller image from this file to be kept on-line. In the future, as the ability to deliver higher-quality images develops, it will be possible to return to the archived file and create a higher-quality image to place on-line without the cost of recapture. This method would help to "future-proof" the initial investment in image capture.

Production projects which capture high-quality images using a digital camera are currently rare; this section focuses on image capture from a photographic surrogate. Scanning requires both a hardware device, a **scanner**, and software that controls part of the scanning process. Often these are bundled in a single package. The software is used for a number of purposes, including controlling exposure, adjusting resolution, framing the image, and storing the digital-image file in an appropriate format.

Scanning can be done in-house, or contracted out. The cost-effectiveness of each approach depends on the volume and type of materials being scanned; the economics of this equation change rapidly with market conditions. The type of scanner chosen for an imaging project will be influenced by whether capture will take place from the original work or from a photographic reproduction. Concerns about preservation may influence the choice of a method that uses a photographic intermediary. Many scanners can handle only transparent material, whereas others can handle only reflective material. Most scanners cannot

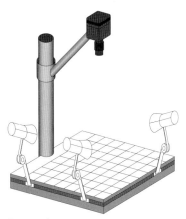

Copystand scanner

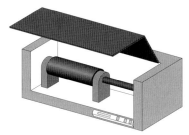

Drum scanner

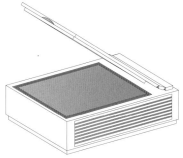

Flatbed scanner

handle source material larger than a particular size. Some scanners require either two-dimensional source material or material pliable enough to wrap around a large drum. Before a scanner or scanning bureau is selected, the nature and characteristics of the source material should be examined to determine all possible limitations.

There are five general types of scanners: copystand, drum, flatbed, slide, and video digitizer (frame-grabber). Each scanner has its own strengths and weaknesses. **Copystand scanners** resemble microfilming stands; a **digital camera** is used in place of a normal film camera. Source material is placed on the stand and the camera is cranked up or down in order to fit the material within its field of view. This allows the scanning of different sizes of originals. **Drum scanners** resemble mimeograph stencil machines from the 1960s; source material is placed on a drum which is then rotated past a high-intensity light source that captures the image. Drum scanners tend to offer the highest image quality, but require flexible source material of limited size that can be wrapped around a drum. **Flatbed scanners** resemble photocopying machines; source material is placed flat on the glass and captured by **CCD arrays** that pass below it. Flatbed scanners require source material to be no larger than the glass and to lie face-down and flat. **Slide scanners** resemble small boxes, with a slot in the side big enough to insert a 35-mm slide. Inside the box, light passes through the slide to hit a CCD array behind the slide. Slide scanners can generally scan only 35-mm transparent source materials. **Video digitizer (frame-grabber)** scanners are circuit boards placed inside a computer, attached to a standard video camera. Anything that can be filmed by a video camera can be digitized by a video frame-grabber, including three-dimensional objects and motion video. Video frame-grabbers offer the fastest scan ($^{1}/_{30}$ second), but are limited by video image quality. Each scanner type has features that make it more appropriate for particular types of collections.

Once the range of scanner types has been narrowed, a choice must be made among the features and capabilities of various models, noting such characteristics as maximum possible resolution and dynamic range. Other features to consider when choosing a scanner include prescanning functions such as **bordering** and **centering**, automatic edge finding, and automatic exposure. A manual override for any automatic function is essential, as the machine will occasionally misjudge the material. Also desirable are postscanning adjustments (such

Slide scanner

as cropping, adjusting brightness, contrast, highlights, or shadow); and image processing of the entire image or just a portion of it (such as dropping-out of background **noise**, **color correction**, and merging text and images from different scans). This **image-manipulation** capability may be needed in-house even if the original image capture is done by a service bureau.

Scanning software should be chosen on the basis of its capabilities, including the ability to save an image file into a wide variety of standard storage formats (including **TIFF**, **GIF**, **JFIF**, **SPIFF**, **PICT**, **TGA**, **EPS**, **CGM**, and **Photoshop**) using a variety of different compression schemes (such as **JPEG**, **JBIG**, **LZW**, and **Quick Time**). This ability will provide the broadest possible range of image-delivery options. Software should also make it possible to import files that may have been created with other scanners, stored in various standard formats, and compressed according to a variety of different schemes. Software utilities that convert image files from one format to another are also useful.

Video frame grabber

An alternative to setting up on-site scanning is to contract with a vendor to scan material off-site. The most cost-effective option for this purpose is currently Kodak's **PhotoCD**. A wide variety of service bureaus offer image capture using this technology as well as others.

Whether scanning is done in-house or off-site, scanning quality can vary widely. Service bureaus offering image capture vary considerably in the quality levels they provide. A variety of sample images should be sent to several vendors and quality compared before any project is actually begun.

Images

The Digital Image

A digital image is composed of a set of pixels arranged according to a predefined ratio of columns and rows. Each pixel represents a single color or gray-scale value.

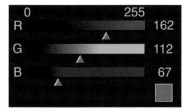

Single pixel information for RGB

Single pixel information for gray scale

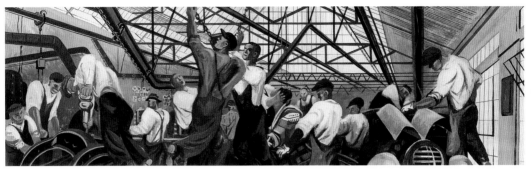

William Gropper, *Automobile Industry* (Mural study, Detroit, Michigan Post Office), 1940–1941, oil on fiberboard, 20⅛ × 48 in. (51.0 × 121.8 cm), National Museum of American Art, Smithsonian Institution

This CMYK pattern represents the printing process as used to reproduce the paintings in this book (magnified ten times).

CMY color

RGB color

Print vs. Monitor Display

A color image is displayed differently on the printed page than on a monitor.

In print, color is represented as light reflecting off ink, in the secondary (subtractive) colors of cyan, magenta, and yellow—**CMYK**—the result of combining pairs of primary colors. When mixed together these create black. However, it is not possible to get a "true" black when mixing printing inks, so a fourth, black ink, is printed (the K in CMYK). Each hue is created by overprinting some or all of these four colors. It is not possible to vary the intensity of the color of the dots in a printed image. Varying tones are achieved by altering the size of each dot, to allow more or less white paper to show through, creating an illusion of luminance.

On a monitor, color is represented with emitted light, as varying intensities of the three primary (additive) light colors: red, green, and blue in **RGB** color. When mixed together, red, green, and blue produce white. The hue of each pixel on the screen is determined by the relative values of red, green, and blue projected onto it. Tone is created by altering the levels of intensity, from white light to fully saturated color.

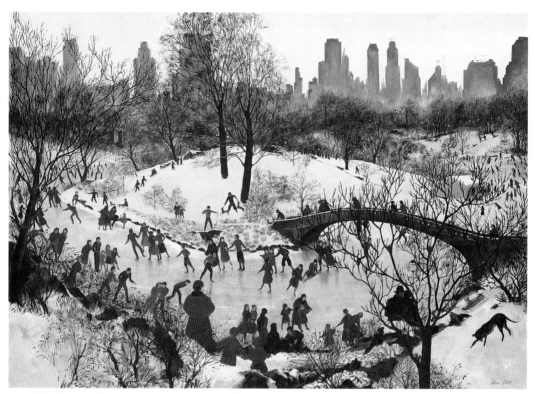

Agnes Tait, *Skating in Central Park*, 1934, oil on canvas, 33⅞ × 48⅛ in. (85.8 × 121.8 cm),
National Museum of American Art, Smithsonian Institution. Transfer from the U.S. Department of Labor

24-bit, more than 16 million possible colors

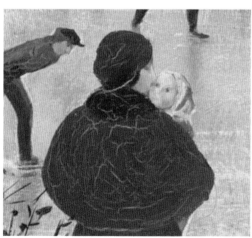

600 DPI

Resolution

These images were sampled from the original scan. They are shown magnified four times, for comparison.

Compression

Uncompressed image
File size 3.0 megabytes (MB)

Lossless compression
File size reduced by 25%
2.2 MB

Lossy compression
File size reduced by 96%
(maximum possible)
121 kilobytes (KB)

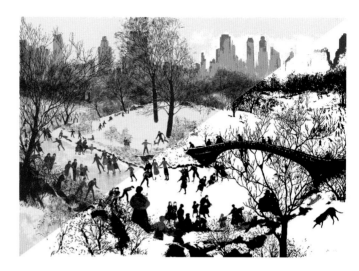

4-bit, 16 colors

Adaptive palette

16 colors closest to the original image chosen from the full RGB palette (16 million colors)

System palette

Up to 16 colors chosen from the 256-color system palette. In this case only 8 colors are suitable.

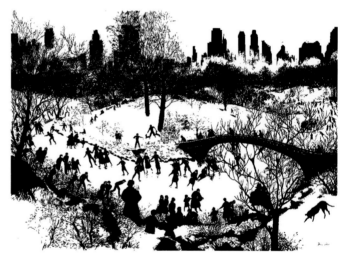

1-bit, 2 colors

Any two colors

60 DPI

30 DPI

Dynamic Range

8-bit, 256 colors

System palette

A uniform sample of RGB colors

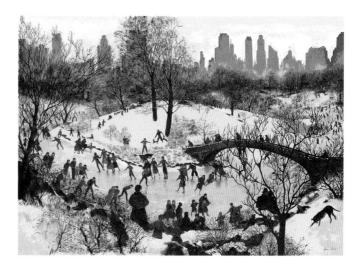

8-bit, 256 colors

Adaptive palette

256 colors closest to the original

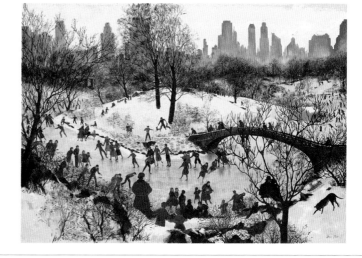

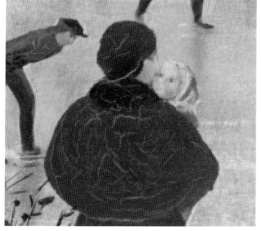

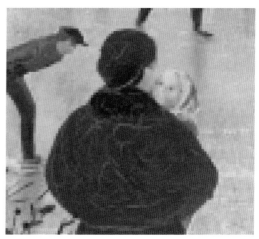

300 DPI

150 DPI

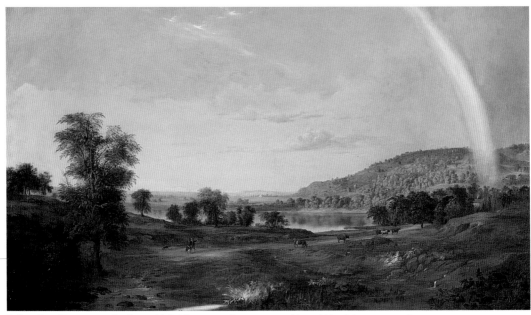

Robert Scott Duncanson, *Landscape with Rainbow*, 1934, oil on canvas, 30⅛ × 52¼ in. (76.3 × 132.7 cm), National Museum of American Art, Smithsonian Institution. Gift of Leonard and Paula Granoff

Image Source

Digital-image quality is dependent on the source material scanned. These images show the relative amount of detail found in an 8 × 10 transparency and a 35-mm slide. Seven times as many pixels compose the same portion of the image, when it is scanned from the larger format.

26

Image Quality

Image quality is the cumulative result of the scanning **resolution**, the **dynamic range** of the scanned image, the source material scanned, the scanning device or technique used, the skill of the scanning operator, and the final display device. Image quality is often expressed in terms of resolution, but other factors also affect the quality of an image file. Images are often stored at much higher quality than they are displayed on a monitor because most printing devices are capable of a much higher resolution than screen displays. When choosing quality levels, system designers must consider effective display and print resolutions and balance them with other image uses.

The quality of a digital image can never exceed that of the source material from which the image is scanned. Differing film types contain different amounts of information. For example, large-scale works, such as tapestries or buildings, might not be adequately depicted in a 35-mm **surrogate image**; such architectural works may require a larger film format (or multiple frames) to capture their full detail. If the desired quality is superior to that of a 35-mm slide, then a higher-quality source (for example, a 4 × 5 transparency) must be scanned *(see Images: Image Source)*.

When image capture takes place from a reproduction, the quality of the resulting digital image is limited by both that reproduction and the capability of the scanning device. Direct capture from an original work offers image quality generally limited only by the capabilities of the scanning device or **digital camera**. It is certainly possible to get a higher-quality image by scanning directly from the original work, but this is a time-consuming process. The exposure to light, heat, and handling required by the digitization process may also pose a threat to the work's preservation. If image quality is acceptable, scanning from slides or transparencies rather than from original works of art will avoid the problems of moving and lighting fragile works, and save significant amounts of time.

A key trade-off in defining an appropriate level of image quality is the balancing of file size and resulting storage requirements with quality needs. The higher the quality of an image, the more storage space it will occupy and the more system resources it will require: higher **bandwidth** networks will be necessary to move it around; more memory will be needed in each workstation to display it; and the scanning process will be longer and costlier. Image compression provides a key to maintaining quality while using less storage space and systems resources *(see Compression)*.

Each institution needs to determine what quality of image is acceptable (in terms of resolution, dynamic range, and compression loss) for its various types of users, and measure this decision against the cost (in resources for image acquisition, delivery, and storage) of various levels of quality. The study "Image Quality and Viewer Perception" (*see* Ester 1990) can help frame these issues. It identifies, on a continuum of image quality, points at which various groups of people could no longer perceive improvement in a digital image, despite higher resolution or increased dynamic range. Such levels could be used as part of a price/performance analysis to determine the thresholds at which users might no longer be well served by more costly higher-quality images.

Choosing an appropriate level of image quality requires balancing user needs, system requirements, network infrastructure, and cost. One strategy for dealing with these issues is to offer images of different quality at different times. Small, low-resolution **browse** or **"thumbnail" images** may be shown quickly to enable the viewer to identify a work, or review large numbers of works; a "medium-resolution" full-screen image may accompany a full catalog record; and a "high-resolution" image may be available for detailed study only on special request *(see Networks)*. Such strategies identify when information is needed and deliver only what is needed at that time.

Quality Control

Quality control must be maintained throughout the development of an image database. Routines must be developed to verify both textual documentation (description and indexing) and image capture. Database records need to be proofread and mechanisms such as valid term lists developed to ensure consistent data entry. Relationships between text records and image files need to be verified. Consistent guidelines and parameters should be established for in-house scanning, and scans must be periodically reviewed and checked for accuracy, ideally against the source material. The quality of vendor-supplied scans must also be regularly reviewed.

Although automatic scanning is frequently consistent, problems with exposure, alignment, and color balance occur often enough to require a quality-control component in any scanning program. Without quality control, it will not be possible to guarantee the integrity and consistency of the resulting digital-image files. Steps should be taken to minimize the variations between different operators and different scanning devices. The operator and device, as well as the settings used, should be recorded for each scan so that possible bias or inaccuracy can be remedied later *(see Technical Standards)*.

Display Devices

Display devices are currently the weakest link in the image-quality chain. Images can be scanned and stored at high levels of quality, and reasonable levels of consistency can be maintained across disparate capture devices. But at present, affordable monitors or projectors are not available to display high-quality images, and it is difficult to maintain rigid consistency among different output devices.

Each model of display and printing device renders color slightly differently. A particular shade of red on one monitor will not necessarily look the same on another. Brightness and contrast may also vary. Some color-calibration tools are now available to minimize these differences. To provide color consistency across devices, **color management systems** using approaches such as Apple's ColorSync or Kodak's Color Sense are designed to map the characteristics of each device into and out of a standard **color space**. Currently these systems are still immature and not widely used. Development has focused primarily on **color correction** for printed output, rather than display. Manual color correction is most accurate when standard reference points—color bars and gray scales—are included in the digital image. Consistently calibrating devices to a standard color target or profile is also essential.

Since improvements in both device quality and techniques for maintaining color consistency are inevitable, it would be short-sighted to optimize the scanning component of an image-database project to reflect the characteristics of a particular display device, or a particular kind of printed output. When planning the image-capture phase of a project, the introduction of future technologies to display images on improved devices and with more consistent color must be kept in mind.

The Working Environment

Implementing an image database requires balancing the needs of known and potential users, the available technological infrastructure to support electronic delivery of images, and the demands on human and financial resources. The number of users, both inside and outside the institution, must be anticipated (at start-up time, at the point of full-scale implementation, and at some future time). The location of users must be considered (all in one place, dispersed within a building, widely dispersed on a campus, or throughout the world). The technological capabilities of user workstations (operating systems, internal memory, storage, display quality, networking capability, and speed) must be defined. Potential use of the images (such as integration with other tools or applications) should also be anticipated *(see Various Users, Various Uses)*.

The means of delivering image data must also be established. On-line access may be offered via digital networks, or the image database may be distributed to each user through a publishing medium (such as **CD-ROM** or **videodisc**). If on-line multi-user networked access is desired, further decisions must be made as to where different capabilities are implemented: for example, on the client's workstation or on a server in a **client/server** system *(see Networks)*.

The file formats to be supported must be identified. For administrative purposes, it may be advisable to store images in a single format (such as **TIFF**, **GIF**, **PICT**, or **JFIF**), although the ability to write images into other file formats is useful for information exchange. Guidelines should be established to ensure that the same version of a chosen format is used across the institution (for example, there are many implementations of TIFF), and that each field in the format selected will be handled in a consistent way *(see Technical Standards)*.

Displaying Images and Text

The choice of an image-database management system will influence how and when images and their accompanying text are displayed. Some systems predetermine how and when images can be shown, limiting options to a "thumbnail" embedded in a display resembling a catalog card or a full-screen image. Other systems allow more flexibility in the display of images and their associated texts, making it possible to view many images at once, and to work with a number of images on-screen.

Most image-database systems store descriptive information about the images in a traditional text-based information retrieval system. An additional field containing the filename of the image is added to each record in this text-based system to link it to an image file. Images are selected by querying the text-based system. When the query is specific enough, the user requests a selected image (or a set of images) to view. Extensions to user-interface software look up the filename field(s) in the text record(s) and display the image(s), often in a new window. Each system handles the text/image relationship in its own way, and standards need to be developed to enable the interchange of image files among systems *(see Research Agenda)*.

Frequently the user will want to display a number of images simultaneously. This requires a browse or thumbnail function that will display dozens of images on the screen simultaneously (each approximately the size of a 35-mm slide). The user should be able to "point and click" on any of these small images in order to view a larger version of that image and/or the full-text record associated with it. Multiple images may also be displayed in a number of windows open on the user's display.

Institutions planning to use such browsing functions should consider what label text their users will need to read when viewing images, and what type of text-record display (if any) should be linked to the image and made available on request. The capabilities of the display system must also be defined. For example, when working with a number of images, the user will want to sort, group, juxtapose, and annotate specific works. A full set of tools for working with digital images has not yet been developed *(see Research Agenda)*.

Networks

Because image files are so large, the construction of a networked image database is likely to affect system resources significantly. Therefore, systems architecture and **network topology** become significant concerns. Compromises in one area often affect performance in another. For example, in image storage traditionally the denser and cheaper storage media (magnetic tapes and optical disks) have had the slowest access time, whereas the disks with the quickest access time are more expensive and have smaller capacity. Trade-offs between storage cost and capacity on the one hand and access speed on the other must be examined carefully. Currently favored mass-storage options include magnetic tape (either on shelves or in a **jukebox**), optical platters (including writable CD-ROM in a jukebox), large magnetic hard disks, or Redundant Arrays of Inexpensive/Independent Disks (**RAID**).

Delivering image files to a user from a central image-server raises issues regarding compression/decompression and transmission. If it is necessary to compress images for storage and transmission, these images must be decompressed at the user's workstation. Systems plans must support decompression software or hardware at each user's workstation. (Decompression at the image-server would mean moving larger files across the network.)

In order to avoid network transmission bottlenecks (especially around an image-server) it may be wise to situate image-servers at multiple sites on the network. The database could be divided among several servers so that a query goes to a particular server, depending on the desired image. Alternatively, redundant copies of the database could be stored in multiple sites on the network; a query would then go to the nearest or least busy server. Each method has its advantages and drawbacks. Splitting the database may require complex routing of queries; duplicating the database creates problems with managing changes and updates.

An alternate strategy to reduce the load of transmitting image files over networks is to provide only limited access to high-quality image files. Only smaller low-quality **derived images** would be available anywhere on the network. Users would be required to go to a specific site to view high-quality images. For example, images might be scanned at a high level of quality and stored on a high-capacity, cheap (but low-access) medium such as CD-ROM. Lower-quality images (browse and/or medium-resolution) might be accessible on-line, but users wanting more quality would have to go to a library or lab and load a CD-ROM

to view a high-quality image. This strategy would meet the need for broad access to an image database without putting undue strain on the network.

Developments in graphical user interface (GUI) software for navigating the Internet and the **World Wide Web**, such as Netscape and Mosaic, have made it possible to offer wide access to an image database. Providing access to image databases using these tools, however, requires that image-storage formats match the capability of user browsers (most of which support **GIF**, and many of which support **JFIF** and **TIFF**), and that accompanying data be available in **Hypertext Markup Language (HTML)**. Such public access to information also requires careful management of intellectual property rights.

It is likely that this kind of access will eventually merge with the type of localized image database that has existed until now. But World Wide Web browsing tools, which have limited query capabilities and stilted displays, currently lack many of the functional capabilities of local image databases.

Security Policy and Procedures

An image database should be built within a framework of institutional policies and procedures. A security policy should address all aspects of creation, modification, manipulation, access, and use of information. Guidelines of this type will protect investment in the collection of both textual and visual information, ensure accuracy and integrity, and guarantee the usefulness of the database as a future resource.

At present, no single technological scheme to protect image integrity is in widespread use. Rather, the security of an image database is ensured by controlling access to the information it contains. Particular types of users may be limited to viewing certain images under particular conditions, or bound by license agreements to use images only for certain purposes. The ability of certain groups to alter or delete information may be restricted. Software can be used to restrict access to authorized users, track the number of uses of images, and monitor user activity. Not unique to image-database management, these are concerns common to the management of all types of networked information resources.

Most schemes that exist to monitor image integrity, and to ensure that an original image is neither altered nor replaced by another, entail wrapping the image in a **digital envelope** (which is examined by the viewing software to see if the "seal" has been broken). Other schemes, such as **watermarks**, also exist to brand images with identifying marks. Watermarks, formed by switching particular bits in a digital image, allow copies of that image to be identified later. **Digital fingerprints** can also be created within image files in a similar manner. Such marks enable an image rights-holder to verify the source of a digital image, and seek legal recourse if it is misused, or if access restrictions are violated *(see Access)*.

Technical Standards

National and international standards for image-file formats and compression methods exist to ensure that data will be interchangeable among systems. Proprietary compression and file-storage formats should be avoided—at the risk of sacrificing interoperability. Standards are maintained and developed by international organizations such as the International Standards Organization (ISO), the International Electrotechnical Committee (IEC), and the International Telecommunications Union (ITU). These committees address a broad range of information technology issues, and have developed standards such as CCITT (now ITU) Group III or Group IV fax compression standards, and the ISO/IEC JTC 29 JPEG and MPEG compression standards for continuous-tone still and moving images and audio. National standards bodies—including the American National Standards Institute (ANSI); the U.S. National Information Standards Organization (NISO); the British Standards Institution (BSI); and the German Deutsches Institut für Normung (DIN)—not only define and endorse their own standards but also support the work of international agencies.

Other collaborative bodies have developed and adopted standards. For example, the Internet Engineering Task Force (IETF) has developed Universal Resource Names/Numbers (**URNs**) and Universal Resource Locators (**URLs**) for identifying and finding resources on the Internet, and Multipurpose Internet Mail Extensions (**MIME**) for embedding multimedia within e-mail messages. The Institute of Electrical and Electronics Engineers (IEEE) also has standards committees and submits its findings to international standards bodies.

Standards are also developed within an industry. Some, such as Kodak PhotoCD, originate from a particular developer; these may or may not be submitted to a formal standards-making process. A number of industry-promoted de facto standards, however, are implemented inconsistently or come in a variety of (often unlabeled) forms. For example, there are such a wide variety of TIFF implementations that many TIFF applications can read certain types of TIFF images but not others. If an institution chooses such an industry-promoted standard, it must select a particular version of the standard, create clear and consistent rules as to how it will implement it (i.e., create a data dictionary defining rules for the contents of each field), and make sure that all user applications support it. Without clear consensus on a particular standard implementation, interoperability and information exchange may be sacrificed.

Research Agenda

Much research remains in the field of image databases, particularly with respect to image-quality needs. Further studies need to stratify types of collections, as well as users and uses of those collections, relating each to a series of required image qualities. A matrix of image users, uses, and quality should be developed that can establish benchmarks against which to evaluate digital-imaging systems.

Finding and describing images and collections of images, especially within a networked environment, remains a critical problem. How can digitized images be located? How does a user find an image or collection that may exist anywhere on a world-wide network, negotiate the rights to use it, and then receive a copy? To resolve these questions it may be necessary to create a registry (or union catalog) of images and collections or some other image locator tool, and a set of standard use agreements. A wide variety of descriptive (and perhaps even delivery) standards will certainly be required.

World-wide access to networked image databases also requires general acceptance of a method to refer to a file's location on a network. Standards for referring to networked information resources are evolving in a more system- and machine-independent direction. Universal Resource Locators (URLs), which are now used to create hypermedia links in **World Wide Web** documents, point to the specific physical address of a file stored on a computer connected to the Internet. URLs will eventually be replaced by a less device- or machine-dependent system such as Universal Resource Names/Numbers (URNs). Rather than referring to a specific computer and directory, URNs refer to a file owner's name or number, making more of a logical link between two documents. The correlation between names or numbers and physical files stored in directories on particular computers can then be managed at each networked site. This separation eases the management of network-accessible World Wide Web resources, reducing the number of dead-ends that a hypertext traveler encounters. The cultural heritage community needs to adopt these standards as they are established. Until systematic naming and referencing systems are implemented, care must be taken to maintain World Wide Web cross references and file references to prevent the frustration of links that lead nowhere.

Documentation standards for images must also be developed. Recent research in this area (such as the Visual Resources

Association's work on defining descriptive standards for surrogate images) needs to be extended to include the technical aspects of digital images. File-format standards need to be expanded to include required technical data. The Still Picture Interchange File Format (**SPIFF**), proposed as an annex to the **JPEG** standard by ISO/IEC JTC 29, has begun to address these issues. Consensus is needed, however, on the range of data elements that constitute a minimal image description. Such a description should be bound to the image file and travel with it, ensuring that the digital visual information it contains can be accurately identified. This information should be recorded locally in recognition of its utility and in anticipation of the development of such a standard.

Development work needs to advance in a number of more technical areas as well. In a **client/server** system, for example, a truly efficient server might not send images with a dynamic range beyond the client workstation's display capability. If the client workstation can decompress certain types of images, the server might send these images to the client in compressed form. Image-servers need to receive descriptions of the client workstation environment (display capabilities, decompression software/hardware, etc.) in a standard way so that only meaningful information is transferred to a user's workstation.

Research is also needed in the area of text/image display. Standards must be created to define the bidirectional links between image-browsing tools and textual databases so that these tools can be used in conjunction with a broad range of text and image databases, including collection-management systems and on-line public access catalogs (OPACs). Image browsers themselves need to be enhanced to support a full range of activities. Tools for working with both text and image, including image annotation, sorting, and linking tools, are essential to support visual research.

Although some of these research questions concern the development of networked information resources in general, others are specific to cultural heritage computing. In order to build consensus around research priorities, the Getty Art History Information Program (AHIP) is developing a profile of the outstanding research questions raised by the conversion of cultural heritage information to digital form, and its transmission over computer networks.

Other Resources

There are many organizations and initiatives active in the area of digital imaging. This section highlights a few which will be of direct interest to the cultural heritage community.

AHIP's Imaging Initiative brings together the many communities interested in the potential for digital imaging to improve access to cultural heritage collections. Finding consensus on the appropriateness of existing standards, collaborating in the development of needed standards, devising common approaches to the management of intellectual property, and improving understanding of imaging technologies will ensure that the full potential of imaging is available to the arts and humanities. Further information can be found on AHIP's World Wide Web site (http://www.ahip.getty.edu/ahip/home.html).

IMAGELIB (imagelib@arizvm1.ccit.arizona.edu) is a **listserv** devoted to image databases, providing a forum for discussing all aspects of image databases in a wide variety of environments including the arts, medicine, and document imaging. This list, moderated by Stuart Glogoff of the University of Arizona, is also available as a Usenet **newsgroup** (bit.listserv.imagelib). A companion gopher server includes a database of image-database projects (gopher: dizzy.library.arizona.edu or http:// dizzy.library.arizona.edu).

Information about standards and methods for describing images can be found in the publications and listservs of the Visual Resources Association (vra-l@uafsysb.uark.edu) and the Art Libraries Society of North America (arlis-l@ukcc.uky.edu). Some of these issues are also reviewed on the Museum Discussion List (museum-l@unmvma.unm.edu, also available as the newsgroup bit.listserv.museum-l).

The Museum Educational Site Licensing Project (MESL), jointly managed by AHIP and MUSE Educational Media, is exploring issues of site licensing and intellectual property control. Seven museums and seven universities are collaborating to develop the terms and conditions for the educational use of museum images and information on campus-wide networks. Information about MESL is available from the AHIP World Wide Web site, or by **ftp** (ftp.ahip.getty.edu/pub/mesl).

The National Initiative for Networked Cultural Heritage (NINCH) is devoted to giving a voice to the arts and humanities community in the course of the development of the National

Information Infrastructure (NII). Its membership comprises numerous professional associations, including the American Council of Learned Societies, the Coalition for Networked Information, and The Research Libraries Group. Further information can be found on AHIP's World Wide Web site.

The Research Libraries Group (http://www-rlg.stanford.edu/welcome.html) and the Commission on Preservation and Access (http://www.cpa.org) have jointly launched a Task Force on Digital Archiving, which is addressing questions of long-term preservation of digital records and recommending strategies for technology refreshment (http://www.oclc.org:5046/~weibel/archtf.html).

Many Internet-accessible databases illustrate the potential for imaging in networked cultural heritage information. The Clearinghouse for Subject-Oriented Internet Resource Guides (http://www.lib.umich.edu/ohhome.html) lists many on-line sites relevant to arts and humanities. ArtSource (http://www.uky.edu/Artsource/artsourcehome.html) lists many sites related to the fine arts. Museum sites are listed both at the University of Michigan (http://www.sils.umich.edu/impact/Museums) and as part of the World Wide Web Virtual Library (http://www.comlab.ox.ac.uk/archive/other).

In order to build our knowledge of activities in cultural heritage computing, AHIP is sponsoring Networked Information Sources in the Arts and Humanities, a project that brings together representative projects and institutions building databases of electronic resources in the arts and humanities to foster cooperation and improve knowledge of and access to information resources in the arts and humanities. Further information can be found on AHIP's World Wide Web site.

Conclusion

Digital imaging holds great promise for providing wider access to the world's cultural heritage. Museum images and information in digital form can be distributed over world-wide or local networks and be used for many different purposes, from enhancement of scholarship and teaching to personal exploration and enjoyment. The potential for developing new audiences and broadening cultural appreciation is far reaching.

In order to take advantage of these opportunities, however, digital-image databases must be constructed to remain relevant beyond a single short-term project, and useful to a wide audience. Careful choices of technology and the use of shared technical and descriptive standards will make it possible to exchange information among databases and across networks. Common approaches will ensure that all cultural heritage institutions can participate fully in the creation of the virtual museum.

Glossary

8-bit image

A digital image that can include as many as 256 possible colors. In this kind of image, 8 bits are allocated for the storage of each **pixel**, allowing 2^8 (or 256) colors to be represented.

24-bit image

A digital image that can include approximately 16 million possible colors. In this kind of image, 24 bits are allocated for the storage of each **pixel**, allowing 2^{24} (or more than 16 million) colors to be represented.

Access points

Index terms used to search a database.

Adaptive palette

Image-specific set of colors chosen to most closely represent those in the original source. Part of a custom color look-up table.

Algorithm

A rule (often mathematical) governing computer processes.

Annotation

Information (such as arrows, pointers, words) added to an image. Annotations to a digital image might be stored in layers separate from the image.

Archival image

An image meant to have lasting utility. An "archival" digital image is generally an image kept off-line in a safe place; it is often of higher quality than the digital image delivered to the user.

Art & Architecture Thesaurus

AAT. One of the structured vocabularies offered by the Getty Art History Information Program (AHIP), the AAT, begun in 1980, is a hierarchical arrangement of more than 90,000 terms in art and architecture. Published in print and electronic forms by Oxford University Press.

Art Information Task Force

AITF. A three-year project jointly sponsored by the Getty Art History Information Program (AHIP) and the College Art Association (CAA) which reached agreement on the categories used to describe works of art. Final results are summarized in **Categories for the Description of Works of Art**.

Artifacts

Visual effects introduced into a digital image in the course of scanning or compression that do not correspond to the image scanned.

Automatic indexing

Indexing of a text done by computer without human intervention (usually by finding the words occurring most frequently within the document).

Bandwidth

The transmission capacity of a communications channel, usually expressed in bits or bytes per second (the former is also called baud rate).

Bit-depth

see **Dynamic range**

Bit-mapped image

An image created from a series of bits and bytes that form **pixels**. Each pixel can vary in color or gray-scale value. Also known as a raster image.

Bordering

Automatically locating the correct edge of an image on a scan so that marking from the edge, frame, etc. is not captured.

Browse image

A small image (usually derived from a larger one). Browse images (often called "thumbnails") permit a user to view a dozen or more images on a single screen.

Buffer

Temporary storage space within a computer system.

Capture device

see **Scanner**

Categories for the Description of Works of Art

The report of the **Art Information Task Force**, which defined information about works of art from a researcher's perspective.

CCD array

Charge-coupled device array. Light-sensitive **diodes** used in scanners and electronic cameras. These usually sweep across an image and, when exposed to light, generate a series of digital signals that are converted into **pixel** values.

CCITT Group III or Group IV

The standards adopted by the International Telecommunications Union (ITU), formerly the Comité consultatif internationale de télégraphique et téléphonique (CCITT), to compress page images. All fax machines in common use employ one or both of these standards.

CD-ROM

Compact Disc Read-Only Memory. A form of write-once, disc-based, random-access data storage, usually mass-produced and distributed as a publication. At present, capable of holding approximately 550 megabytes of data.

Centering

Positioning an image properly within the digital field of vision so that it is framed appropriately.

Client/server

A systems architecture design that divides functions (which might be part of a single application) between two or more computers. The client is the machine that requests information; the server is the machine that supplies it. A typical client/server architecture for imaging might allow a server to store and transmit a compressed file, and the client to decompress, process, and display the image.

CGM

Computer Graphics Metafile. An image-file format designed to handle a wide range of image types, but currently used primarily for **vector graphics**.

CMYK

Cyan Magenta Yellow Black. A system for reproducing color in print, which creates the color spectrum using cyan, magenta, yellow, and black. Used in four-color printing.

Color correction

The process of altering colors as they appear in a digital image or in print to ensure they accurately represent the work depicted.

Color depth

see **Dynamic range**

Color look-up table (CLUT)

see **Palette**

Color management systems

Systems that attempt to produce consistency in the representation of color in image files, across image capture, display, and output devices.

Color space

A means of representing the color spectrum.

Compression/ Decompression

Compression is the process of squeezing more data into a smaller storage space. Decompression is the retrieval of compressed data and its reassembly to resemble its original form (before compression).
see also **Lossless compression, Lossy compression**

Copystand scanner

A type of image-capture device that sits on a copystand and can be raised or lowered to get closer to or farther from the material to be scanned. Involves a physical set-up similar to microfilming, or copy photography.

Decompression

see **Compression**

Derived image

An image that is created from another image, usually by eliminating part of it. Common techniques used to create a derived image include taking a detail, **subsampling** to a lower resolution, using **lossy compression**, or using

image-processing techniques to alter an image. Also called derivative image.

Digital camera

A camera that directly captures a **digital image** without the use of film.

Digital envelope

A digital "container" that surrounds an image with information (or metadata). Such information might be used to find the image, guarantee its authenticity, or limit access to authorized users.

Digital fingerprint

see **Watermark**

Digital image

An image composed of bits and bytes. *see* **Bit-mapped image** or **Vector graphic**

Digitizing

To convert an image into binary code. Visual images are digitized by scanning them and assigning a binary code to the resulting **vector graphic** or **bit-mapped image** data.

Diodes

Light-sensitive electronic components used in image capture. They function as one-way valves that sense the presence or absence of light and create a digital signal that the computer converts into **pixel** values.

Documentation

Textual information that describes a work of art or image, recording its physical characteristics and placing it in context.

Download

The transfer of information from one computer to another. Frequently used to describe file transfer from a network file server to a personal computer.

DPI

Dots per inch. A measurement of the scanning resolution of an image or the quality of an output device. Expresses the number of dots a printer can print per inch, or monitor can display, both horizontally and vertically. A 600-dpi printer can print 360,000 (600 × 600) dots on one square inch of paper.

Drum scanner

A high-quality image-capture device. The image to be captured is wrapped around a drum that spins very fast while a light source scans across it to capture a digital version of the image.

Dynamic range

The color depth (or possible **pixel** values) for a digital image. The number of possible colors or shades of gray that can be included in a particular image. **8-bit images** can represent as many as 256 colors; **24-bit images** can represent approximately 16 million colors.

EPS

Encapsulated PostScript. An image-storage format that extends the **PostScript** page-description language to include images.

Flatbed scanner

An image-capture device resembling a photocopy machine. The object to be scanned is placed face-down on a glass plate. The **CCD array** passes beneath the glass.

FTP

File transfer protocol. A method of moving or transferring files between computers on the Internet.

Full-screen image

A digital image covering the entire screen of a workstation.

Frame-grabber

see **Video digitizer**

GIF

Graphic Image File format. A widely supported image-storage format promoted by CompuServe that gained early widespread use on on-line services and the Internet.

Gray scale

The range of shades of gray in an image. The gray scales of scanners and terminals are determined by the number of grays, or steps between black and white, that they can recognize and reproduce.
see also **Dynamic range**

Header

Technical information packaged with an image file, which may be of use in displaying the image (e.g., length and width in pixels), identifying the image (e.g., name or source), or identifying the owner.

Hypertext Markup Language

HTML. An encoding format for identifying and linking electronic documents used to deliver information on the **World Wide Web**.

ICONCLASS

A system of letters and numbers used to classify the iconography of works of art, developed in the Netherlands.

Image capture

Employing a device (such as a scanner) to create a digital representation of an image. This digital representation can then be stored and manipulated on a computer.

Image manipulation

Making changes to a digital image using **image processing**.

Image processing

The alteration or manipulation of images that have been scanned or captured by a digital recording device. Can be used to modify or improve the image by changing its size, color, contrast, and brightness, or to compare and analyze images for characteristics that the human eye could not perceive unaided. This ability to perceive minute variations in color, shape, and relationship has opened up many applications for image processing.

Imagepac

File-storage format used with Kodak's PhotoCD.

JBIG

An international compression standard designed for images with very little color or gray scale (such as images of document pages).

JFIF

JPEG File Format. File-storage format for images compressed with the **JPEG algorithm**.

JPEG

Joint Photographic Experts Group. Used to refer to the standard they developed for still-image compression, which is sanctioned by the International Standards Organization (ISO).

Jukebox

A stand-alone device that can hold several optical disks or magnetic tapes at a time, making it possible to switch among them at will.

Library of Congress Subject Headings

LCSH. A controlled vocabulary of terms commonly used to retrieve library materials.

Listserv

An Internet mail program, which distributes copies of e-mail messages to the subscribers of a mailing list.

Lossless compression

A process that reduces the storage space needed for an image file without loss of data. If a digital image that has undergone lossless compression is decompressed, it will be identical to the digital image before it was compressed. Document images (i.e., in black and white, with a great deal of white space) undergoing lossless compression can often be reduced to one-tenth their original size; continuous-tone images under lossless compression can seldom be reduced to one-half or one-third their original size.

Lossy compression

A process that reduces the storage space needed for an image file. If a digital image that has undergone lossy compression is decompressed, it will differ from the image before it was compressed (though this difference may be difficult for the human eye to detect). The most effective lossy-compression **algorithms** work by discarding information that is not easily perceptible to the human eye.

LZW

Lempel-Ziv-Welch. A proprietary lossless data-compression **algorithm**.

MIME

Multipurpose Internet Mail Extensions. A standard for embedding multimedia data in e-mail messages.

MPEG

Motion Picture Experts Group. Used to refer to an image-compression scheme for full-motion video they developed, which is ISO-sanctioned. MPEG takes advantage of the fact that full-motion video is made up of many successive frames, often consisting of large areas that don't change, such as blue sky background. MPEG "differencing" notes differences, or lack of them, from one frame to the next.

Network topology

The arrangement of computers and storage devices on a network. Different topologies will create higher use on various segments of the network.

Newsgroup

An Internet discussion group devoted to a particular topic.

Noise

Data or unidentifiable marks picked up in the course of scanning or data transfer that do correspond to the original.

OPAC

On-line public access catalog. A common term for automated, computerized library catalogs, made available to a wide range of users.

Palette

The set of colors that appear in a particular digital image. Becomes part of a color look-up table.
see **Adaptive palette** and **System palette**

Pattern recognition
Computer-based recognition of forms or shapes within an image.

PhotoCD
A popular storage method for digital images. In the basic Kodak PhotoCD configuration, five different levels of image quality are stored for each image in an **Imagepac**.

Photoshop
A sophisticated software program, produced by Adobe Systems, for editing and processing of images.

PICT
Macintosh Picture. A storage format for digital images designed primarily for the Macintosh.

Pixel
The picture elements that make up an image, similar to grains in a photograph or dots in a half-tone. Each pixel can represent a number of different shades or colors, depending upon how much storage space is allocated for it.
see **8-bit image** or **24-bit image**

Quality control
Techniques ensuring that high quality is maintained through various stages of a process. For example, quality control during image capture might include comparing the scanned image to the original and then adjusting colors.

Quick Time
A compression scheme for moving and still images. Originally designed for Macintosh computers.

RAID
Redundant Array of Inexpensive/ Independent Disks. A storage device that uses several disks working together to provide large storage capacity and redundant backup. The use of a set of cheap small disks instead of a single large disk.

Raster image
see **Bit-mapped image**

Resolution, image
Number of pixels (in both height and width) making up an image. The higher the resolution of an image, the greater its clarity and definition.

Resolution, output
The number of dots per inch, **dpi**, used to display an image on a display device (monitor) or in print.

RGB
Red Green Blue. An additive system for representing the color spectrum using combinations of red, green, and blue. Used in video display devices.

Scanner
A device for capturing a digital image.
see **Copystand**, **Drum**, **Flatbed**, and **Slide scanner**

Scanning
see **Image capture**

Slide scanner
A scanner with a slot to insert 35-mm slides; usually capable of scanning only 35-mm transparent material.

SPIFF
Still Picture Interchange File Format, proposed by ISO JTC 29, WG1 as a standard file format.

Structured vocabularies
Vocabularies that make scholarly communication and access to information more consistent.

Subsampling
Using an **algorithm** to derive a lower-resolution digital image from a higher-resolution image (for example, eliminating every other pixel in each direction).
see **Derived image**

Sun raster image
A file-storage format used widely on Sun-3 computers.

Surrogate image
A representation, usually in photographic form, used for study.

System palette
A color palette chosen by a computer system and applied to all digital images.

TGA
TrueVision Targa file. A storage format for **bit-mapped** video images.

Thesaurus of Geographic Names
TGN. One of three structured vocabularies produced by the Getty Art History Information Program (AHIP), TGN is a hierarchical arrangement of more than 300,000 of the world's place names, in vernacular languages and English, and in ancient and modern forms. Available on CD-ROM from the Getty Art History Information Program.

Thumbnail image
see **Browse image**

TIFF
Tagged Image/Interchange File Format. A file-storage format implemented on a wide array of computer systems. Considered an industry standard, but so open that header information is used in many different ways.

True-color image
Generally refers to **24-bit** (or better) images.

Union List of Artist Names
ULAN. One of three structured vocabularies produced by the Getty Art History Information Program, ULAN comprises 200,000 variant names referring to approximately 100,000 artists. Published in print and electronic forms by G.K. Hall.

URL
Uniform Resource Locator. A standard addressing scheme used to locate or reference files on the Internet. Used in **World Wide Web** documents to locate other files. A URL gives the type of resource (scheme) being accessed (e.g., gopher, ftp) and the path to the file. The syntax used is: scheme:// host.domain[:port]/path/filename

URN

Universal Resource Name/Number. A storage-independent scheme under development to name all resources on the Internet, which is likely to be adopted by the Internet Engineering Task Force by late 1996. URNs are likely to supersede **URLs** (Universal Resource Locators) for identification and referencing of networked resources.

Vector graphic

A digital image encoded as formulas that represent lines and curves.

Video digitizer

An image-capture device that employs a video camera attached to a circuit board in a computer which converts the video signal into a digital file. Also called a frame-grabber.

Videodisc

Optical disk storage medium for video images. Can store 108,000 still images.

Watermark

Bits altered within an image to create a pattern which indicates proof of ownership. Unauthorized use of a watermarked image can then be traced.

World Wide Web

WWW. An interconnected network of electronic hypermedia documents available on the Internet. WWW documents are marked up in **Hypertext Markup Language**. Cross references between documents are recorded in the form of **URLs**.

Zooming

Enlarging a portion of an image in order to see it more clearly or make it easier to alter. Opposite of zoom-out, which is useful for viewing the entire image when the full image is larger than the display space.

Bibliography

Collections of articles

	Electronic Imaging and Museums. *Visual Resources* 7, 1991.
Bearman, David (ed.)	*Hypermedia and Interactivity in Museums : Proceedings of an International Conference.* 1991, 1994.
Corti, Laura (ed.)	*International Conference on Automatic Processing of Art History Data and Documents, September 24–27, 1984.* Pisa, Italy : 1984.
Hemsley, James, et al. (eds.)	*Proceedings of the 1994 Electronic Imaging and the Visual Arts Conference, EVA '94.* Fleet, UK : Brameur Ltd., 1994.
Gordon, Marlene E. (ed.)	Image Databases in North America. Special issue of *Computers in the History of Art* 4 (2), 1994.
Lynch, Clifford, and Lois Lunin (eds.)	Perspectives: Advanced Applications of Imaging. Special issue of *Journal of the American Society for Information Science* (September 1991).
Schmitt, Marilyn (ed.), Elizabeth Blakewell, William O. Beeman, and Carol McMichael Reese	*Object, Image, Inquiry : The Art Historian at Work.* Santa Monica, CA: The Getty Art History Information Program; New York, NY : Oxford University Press, 1989.
Stam, Deidre, and Angela Giral (eds.)	Linking Art Objects and Art Information. Special issue of *Library Trends* 37 (2) (Fall 1988).
Sundt, Christine L. (ed.)	Issues in Electronic Imaging. Special issue of *Visual Resources* 10, 1 (1994).

Single articles

Bearman, David	"Considerations in the Design of Art Scholarly Databases," *Library Trends* 37, 2 (Fall 1988) : 206–219.
Benemann, William E.	"Reference Implications of Digital Technology in a Library Photograph Collection," *Reference Services Review* 22, 4 (Winter 1994) : 45–50.
Besser, Howard	"Adding an Image Database to an Existing Library and Computer Environment : Design and Technical Considerations," *ASIS 1991 Midyear Proceedings: Multimedia Information Systems*, 1992.
——	"Digital Images for Museums," *Museum Studies Journal* 3, 1 (Fall–Winter 1987) : 74–81.
——	"Image Databases," *Encyclopedia of Library and Information Sciences* 53 : 16, New York : Marcel Dekker, 1994, 1–15.
——	"User Interfaces for Museums," *Visual Resources* 7 (1991) : 293–309.
——	"Visual Access to Visual Images : The UC Berkeley Image Database Project," *Library Trends* 38, 4 (1990) : 787–798.
Besser, Howard, and Maryly Snow	"Access to Diverse Collections in a University Setting: The Berkeley Dilemma," in *Beyond the Book : Extending MARC for Subject Access to Non-Traditional Materials*, Pat Moholt and Toni Petersen (eds.). New York, NY : G.K. Hall & Co. (1990).
Brilliant, Richard	"How an Art Historian Connects Art Objects and Information," *Library Trends* 37, 2 (1988) : 120–129.

Cawkell, A.E.	"Developments in Indexing Picture Collections," *Information Services and Use* 13, 4 (1993) : 381–388.
Cox, Jennifer, and Mohamed Taleb	"Images on the Internet: Enhanced User Access," *Database* 17, 4 (August 1994) : 18–22, 24–26.
Davis, Ben	"Digital Museums," *Aperture* 136 (Summer 1994) : 68–70.
Ester, Michael	"Digital Images in the Context of Visual Collections and Scholarship," *Visual Resources* 10, 1 (1994) : 11–24.
———	"Image Quality and Viewer Perception," *Leonardo* 23, 1 (1990) : 51–63.
Hamber, Anthony	"The VASARI Project," *Computers and the History of Art* 1, 1 (1991) : 3–19.
Kessler, Benjamin R.	"Electronic Images in Visual Resource Collections," *Visual Resources* 10, 1 (1994) : 1–10.
Lu, Kathleen	"Technological Challenges to Artists' Rights in the Age of Multimedia: The Future Role of Moral Rights," *Reference Services Review* 22, 1 (1994) : 9–19.
Martinez, Kirk	"High Resolution Digital Imaging of Paintings: The VASARI Project," *Microcomputers for Information Management* 8, 4 (December 1991) : 277–83.
Murray, James D., and William Van Ryper	*Encyclopedia of Graphics File Formats.* Sebastopol, CA : O'Reilly & Associates (1994).
Rees, Jeremy	"Interactive Multimedia—The Brancusi Project : An Exploration in International Collaboration," *Information Services and Use* 13, 4 (1993) : 297–302.
Steiner, Christine	"Controlling Your Images—The Museum and the Licensing of Imaging Products," *Museum News* 71, 4 (July/August 1992) : 62–64.
Sunderland, John	"Electronic Imaging and the Visual Arts: A Review of the Conference Held at Imperial College, London, July 23–27, 1990," *Computers and the History of Art* 1, 1 (1991) : 55–61.